Mount Forest Ontario in Photos, Saving Our History One Photo at a Time

Photography
by Barbara Raué
2012

Series Name:
Cruising Ontario

Book 9: Mount Forest

Cover photo: Downtown

Series Name: Cruising Ontario

Book 1: London
Book 2: Dundas
Book 3: Hamilton
Book 4: Oakville
Book 5: Chesley
Book 6: Stoney Creek
Book 7: Waterdown
Book 8: Owen Sound
Book 9: Mount Forest
Book 10: Dundalk

Other Books by Barbara Raue

Coins and Gems

Arrows, Indians and Love

The Life and Times of Barbara
Volume 1: Inventions That Have Enhanced My Life
Volume 2: Entertainment That I Have Enjoyed
Volume 3: East Coast Trip 2009

Mount Forest

Mount Forest is located at the junction of Highways 6 and 89 on a height of land near the headwaters of the Saugeen River. In 1871, eighteen years after the town was surveyed, it had ten hotels, eight churches and eighteen stores; the first train came into Mount Forest later that year.

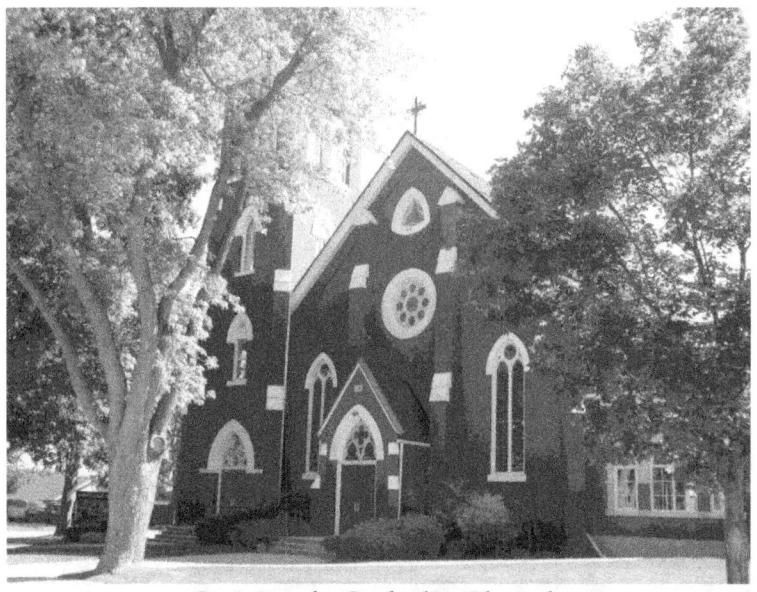

St. Mary's Catholic Church

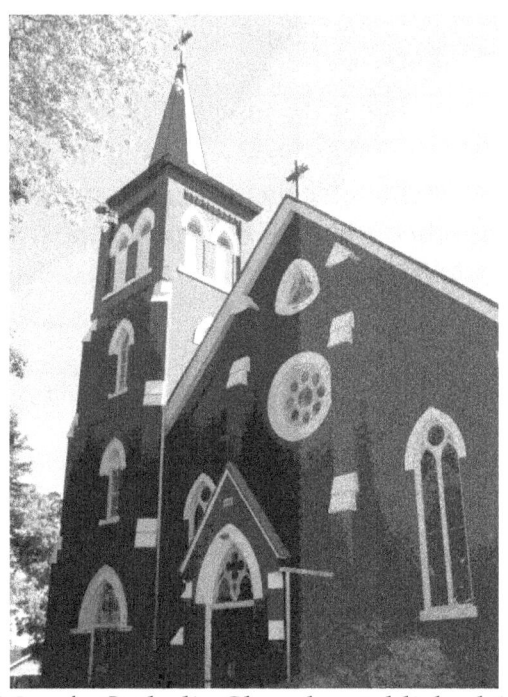

St. Mary's Catholic Church established 1863

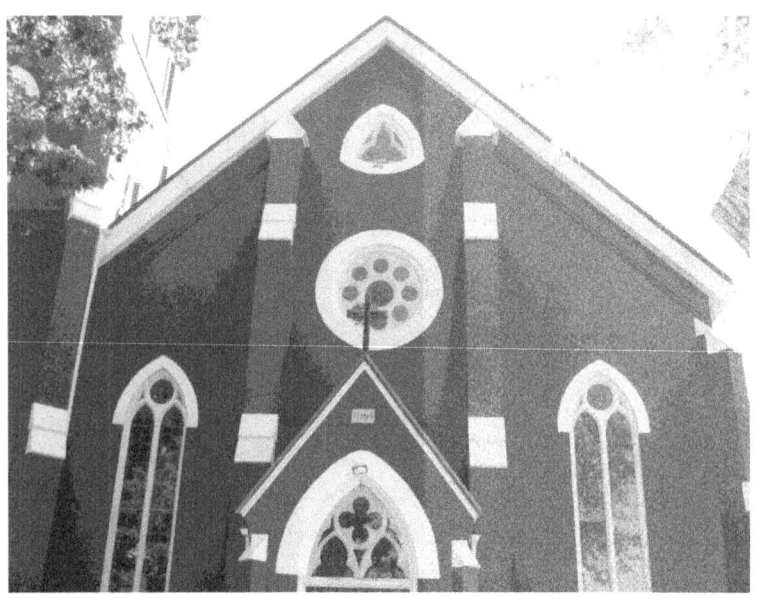

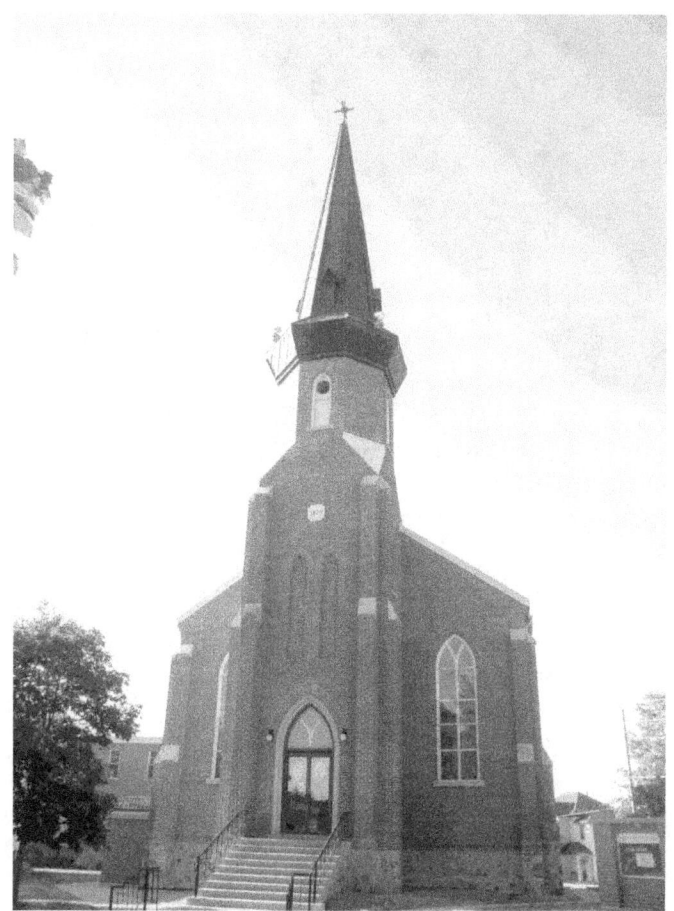
Mount Forest United Church – 1873

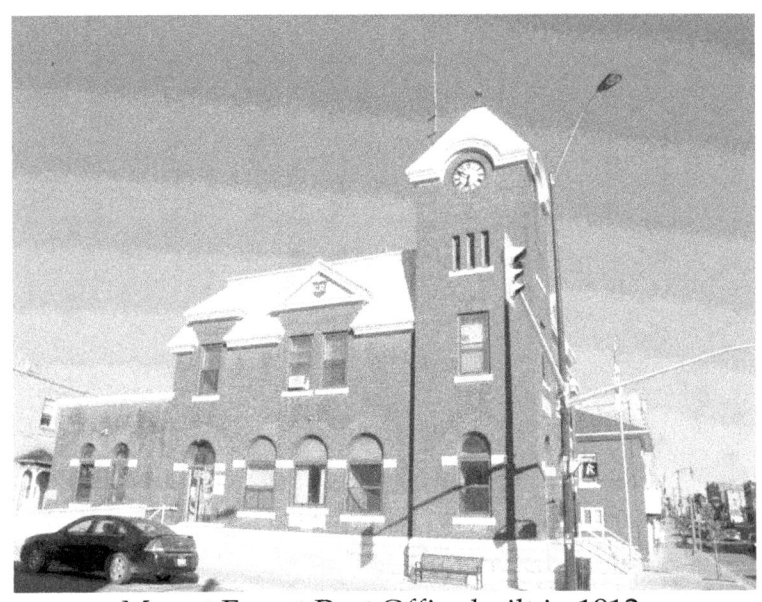

Mount Forest Post Office built in 1912.
The timepiece for the clock tower was made in Birmingham, England. There are Gothic style arched windows.

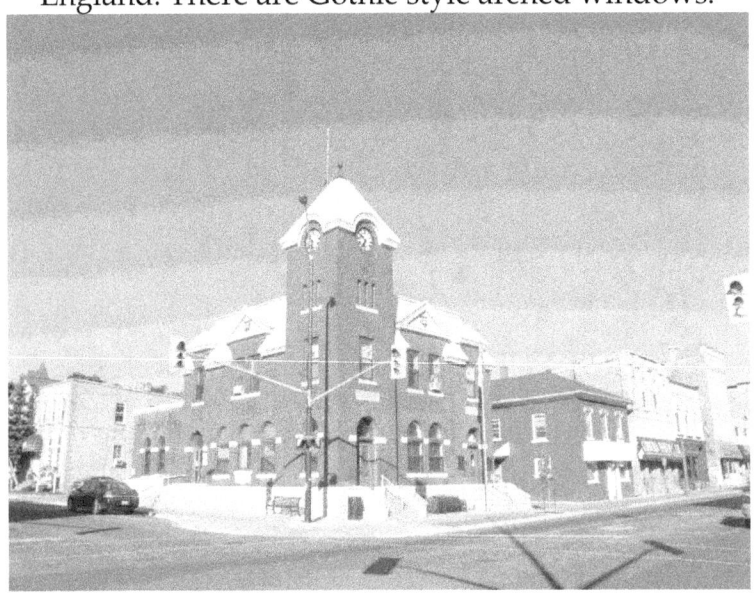

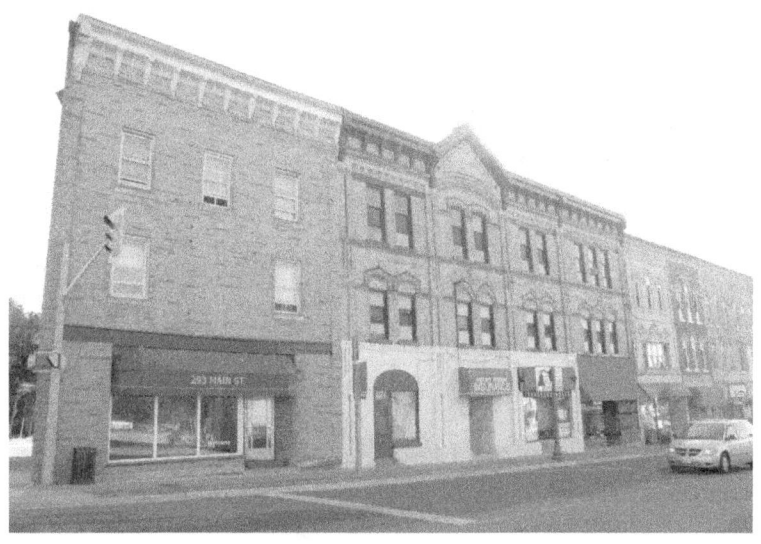

Downtown

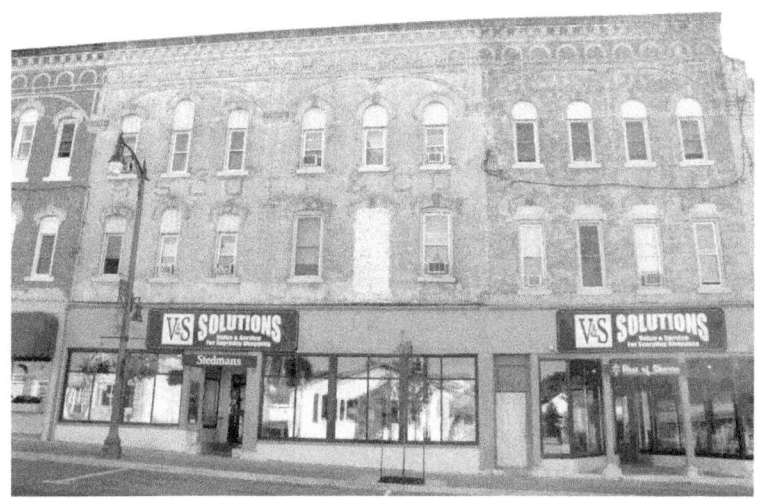

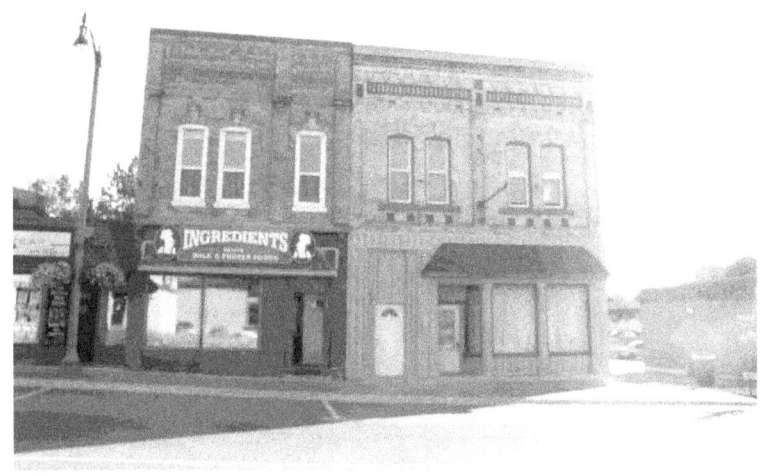

Decorative two-tone brickwork

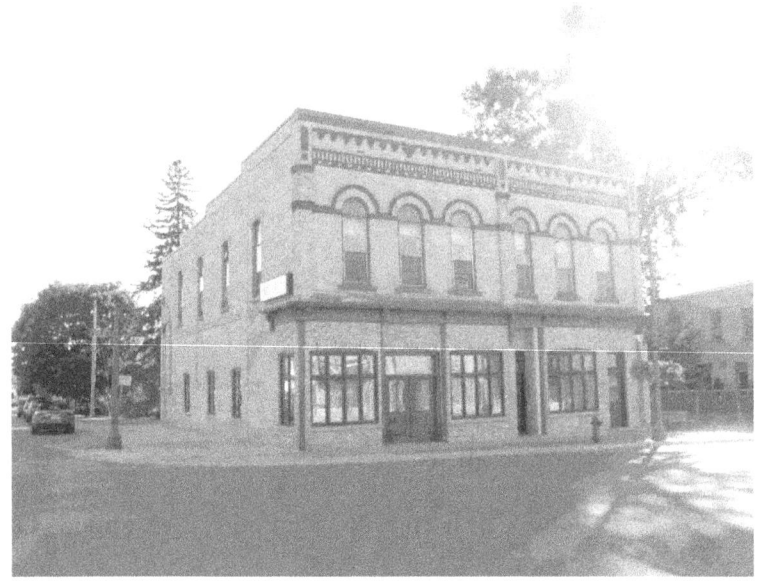

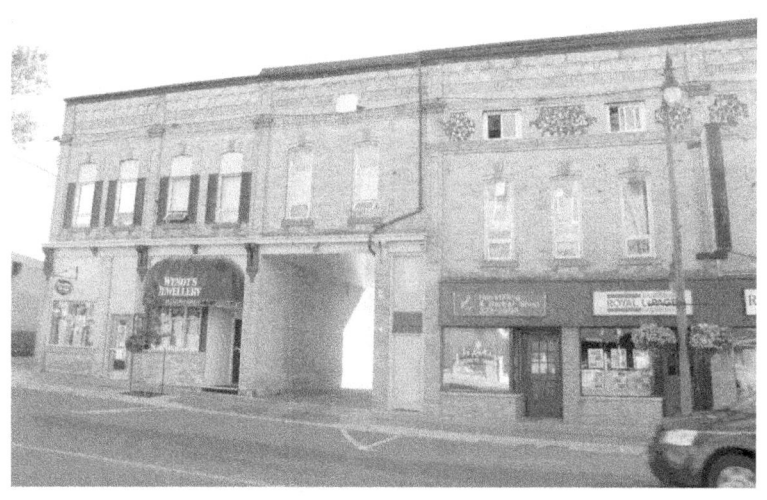

Dickson Block - 1887

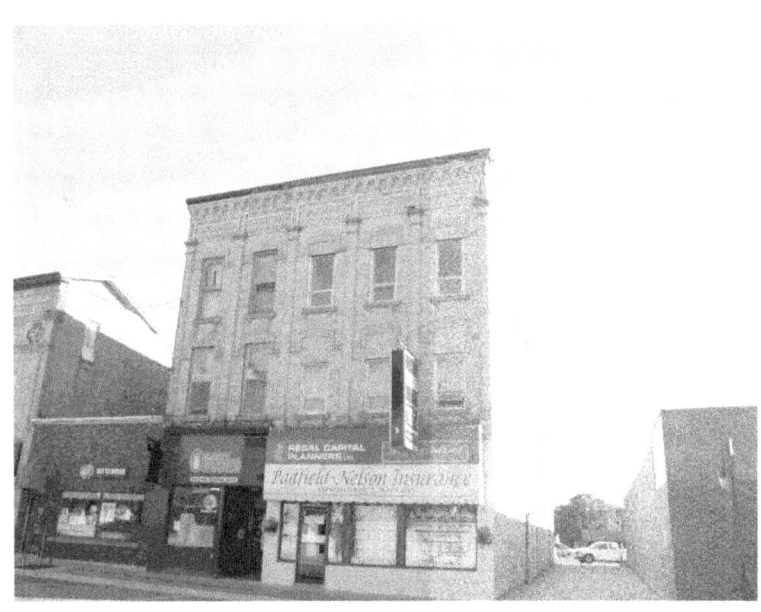

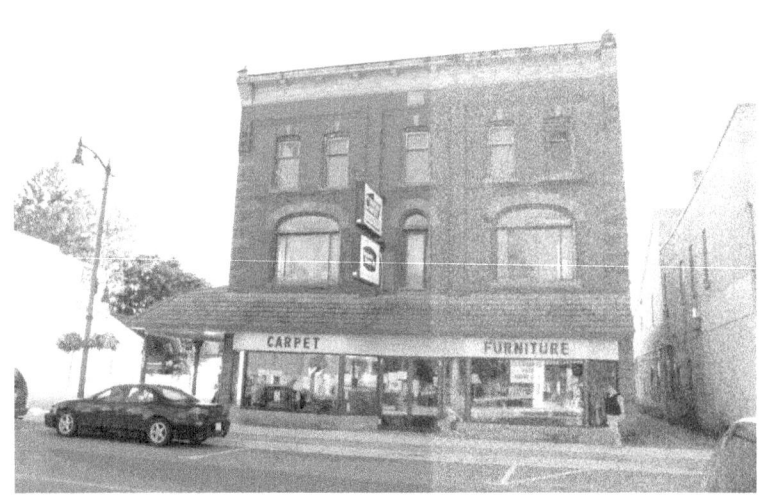

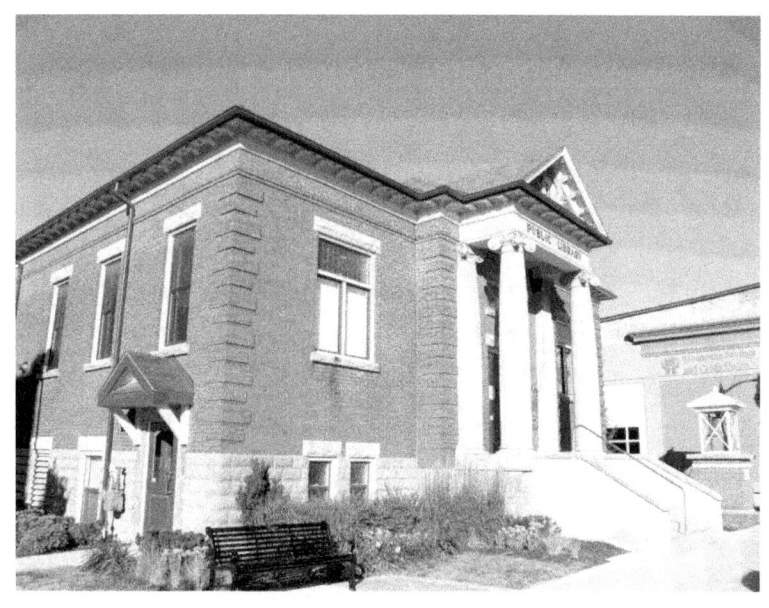

Public Library opened in 1913
118 Main Street North

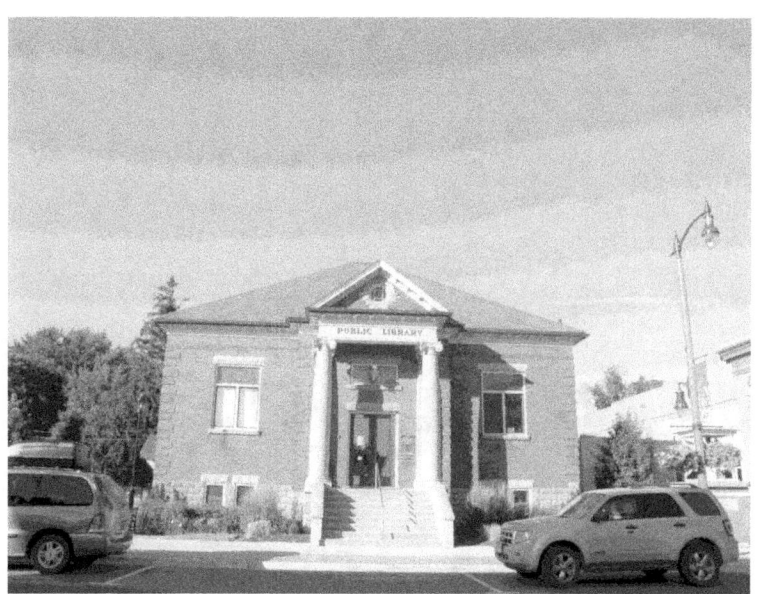

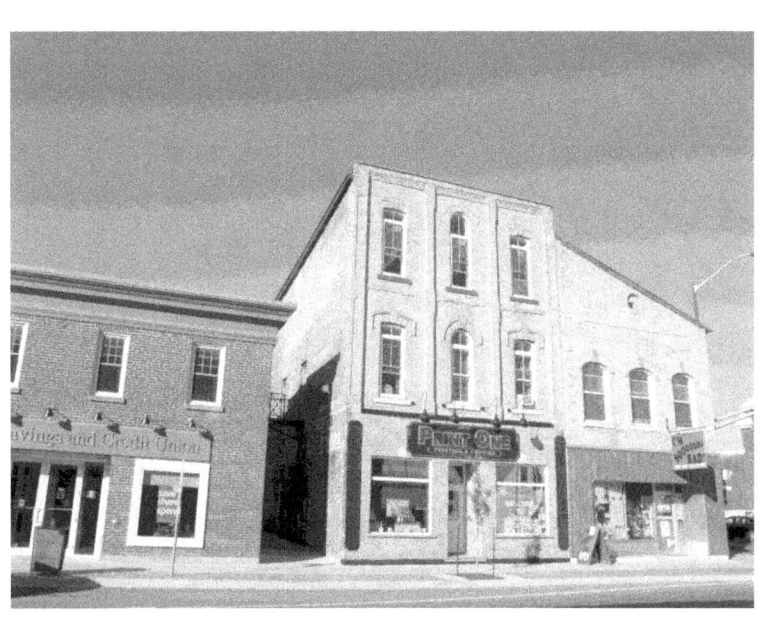

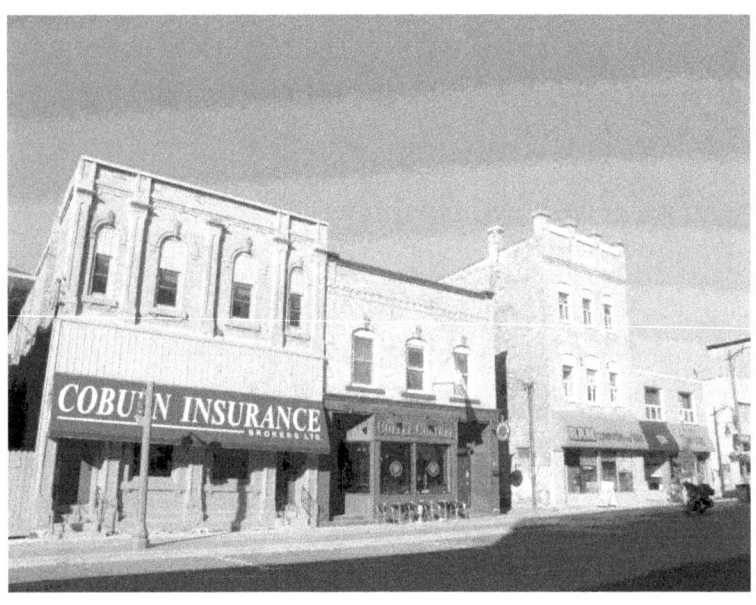

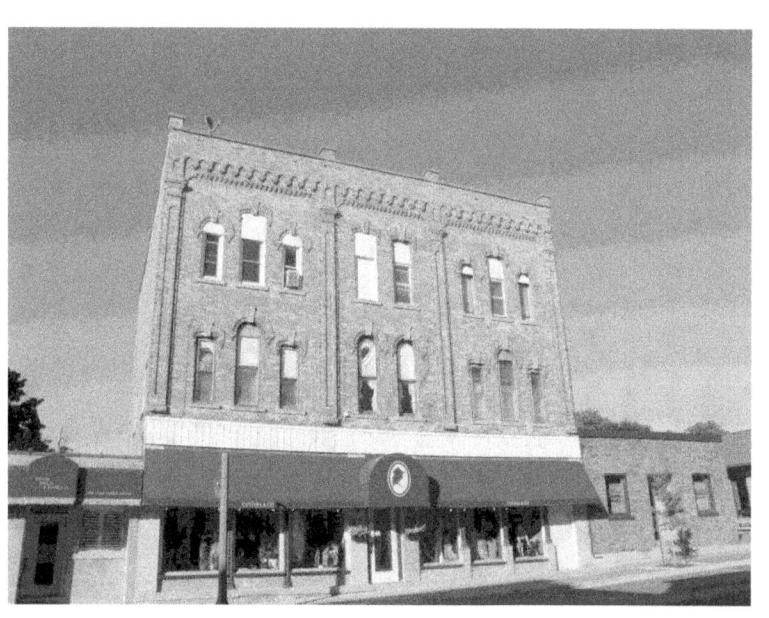

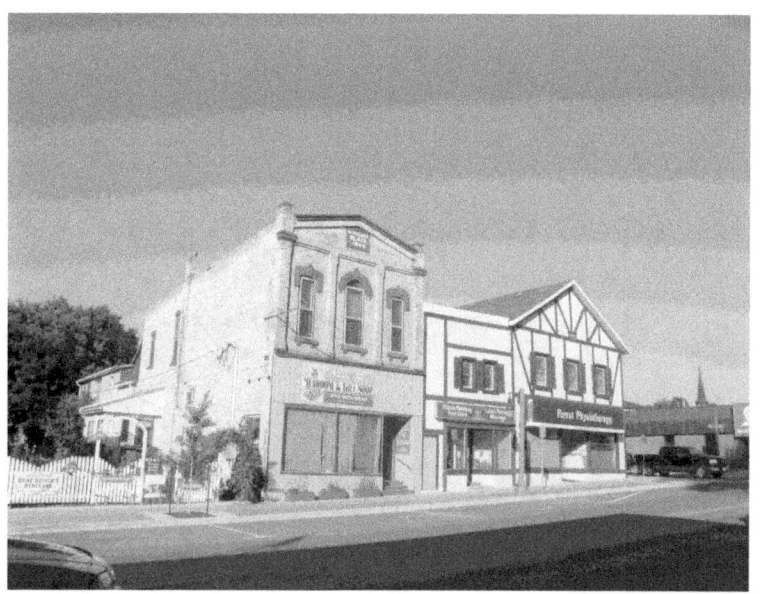

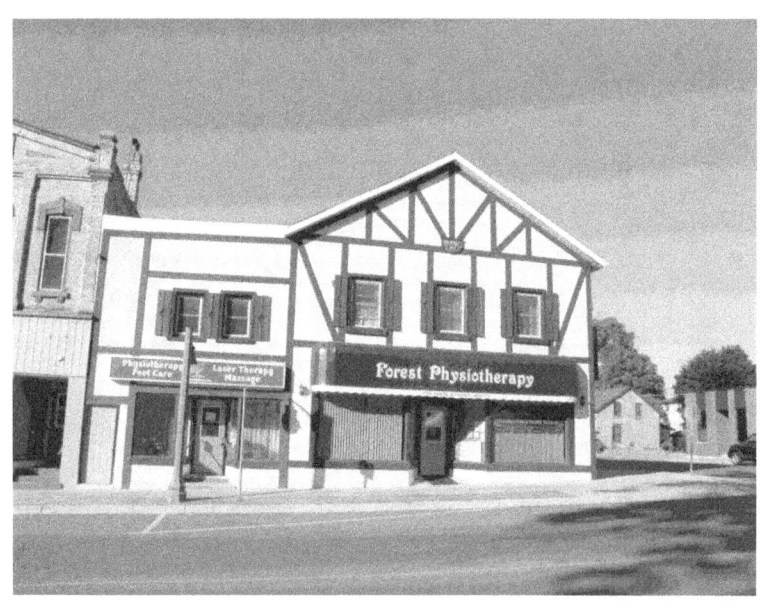

#321

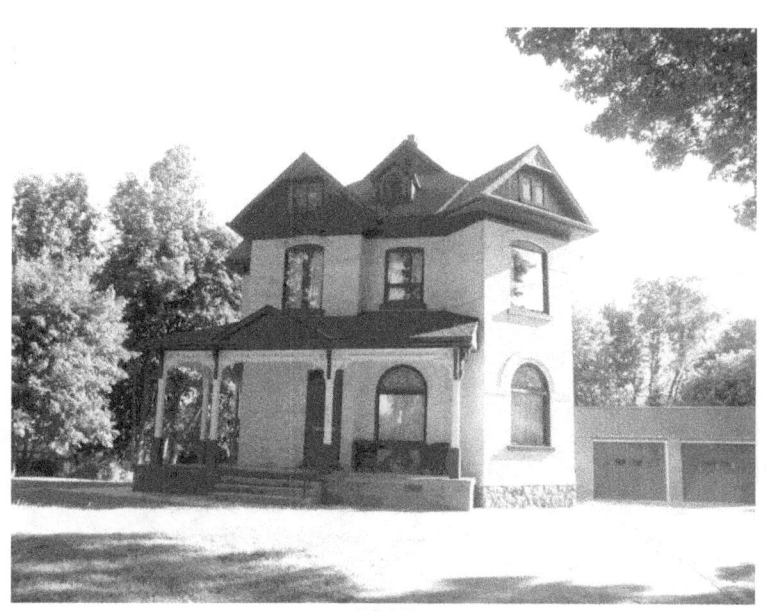

#315

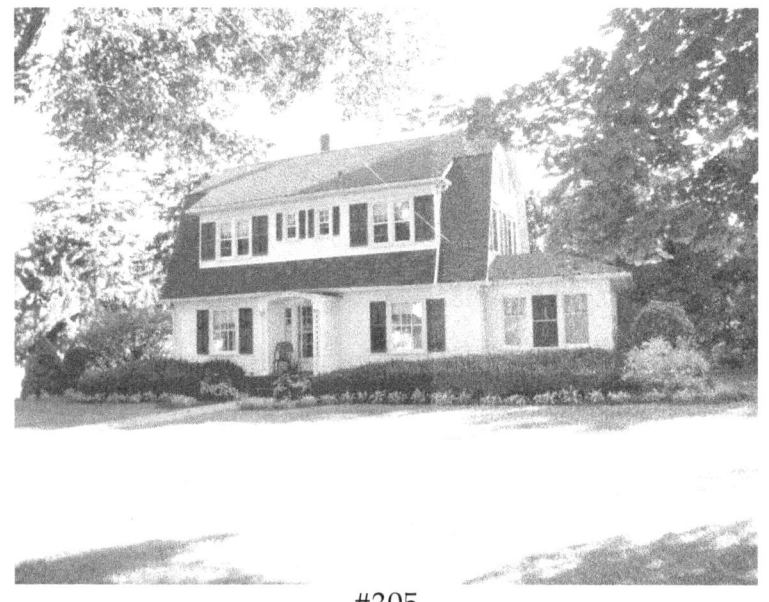

#305

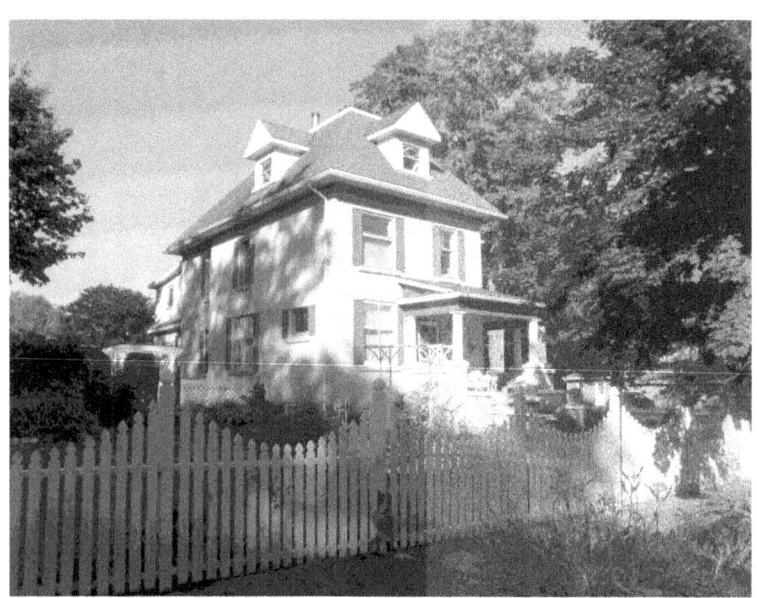

#308

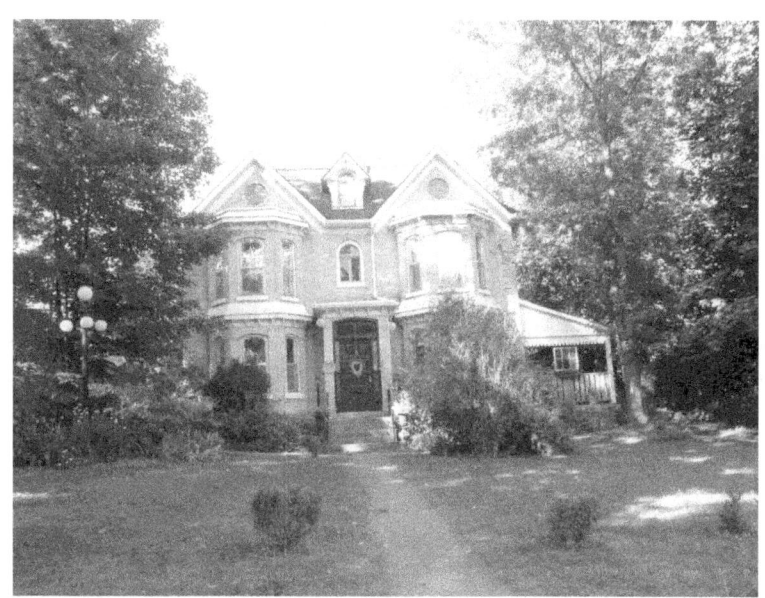

#270

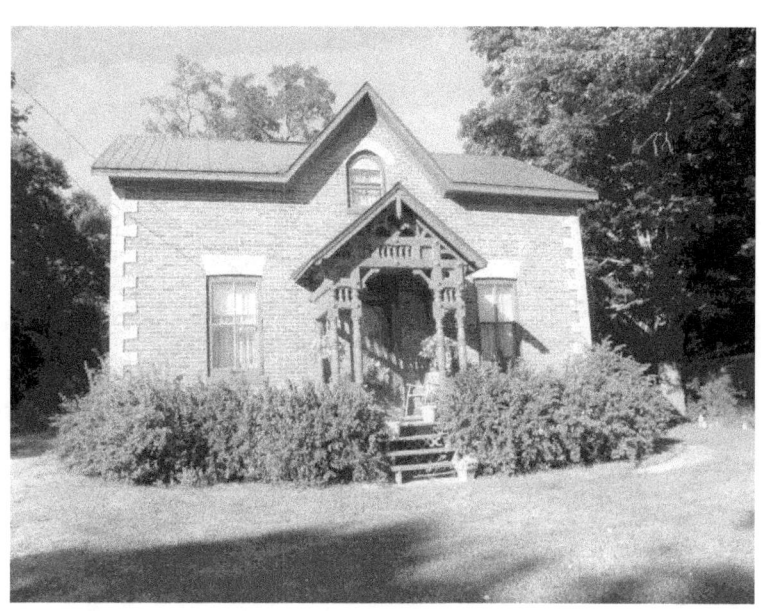

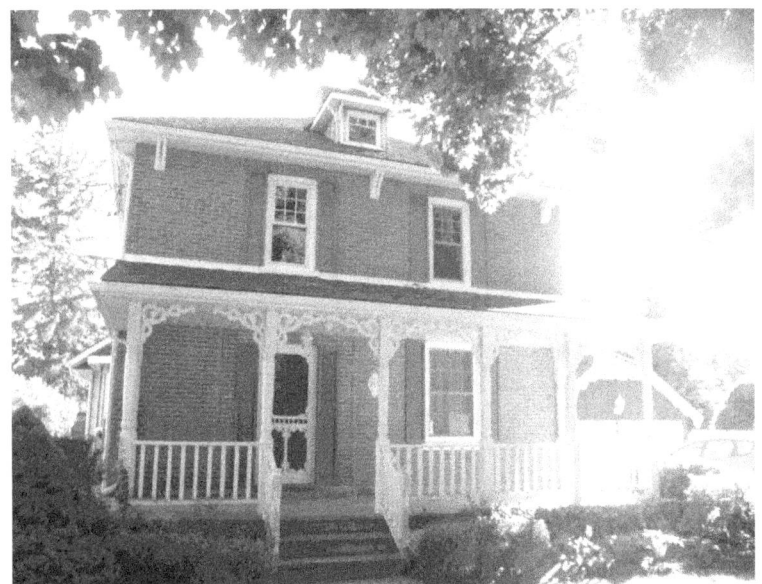

#267

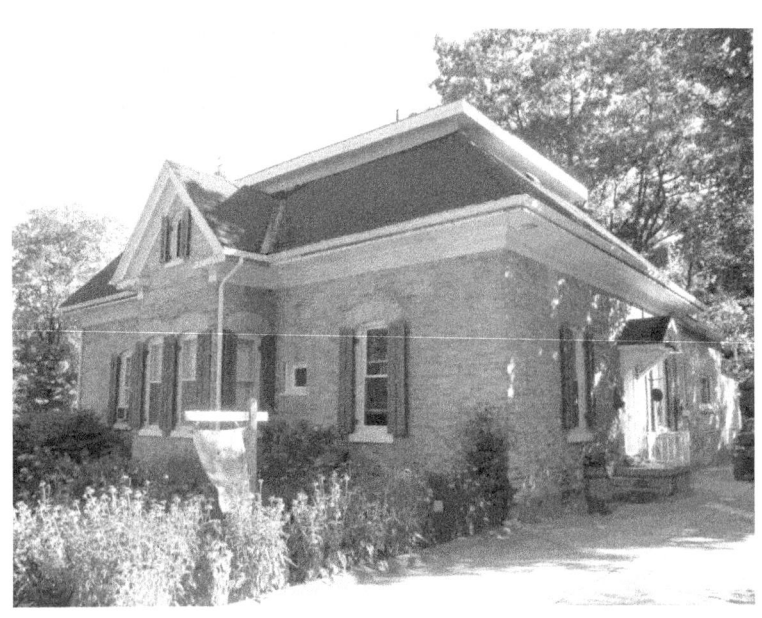

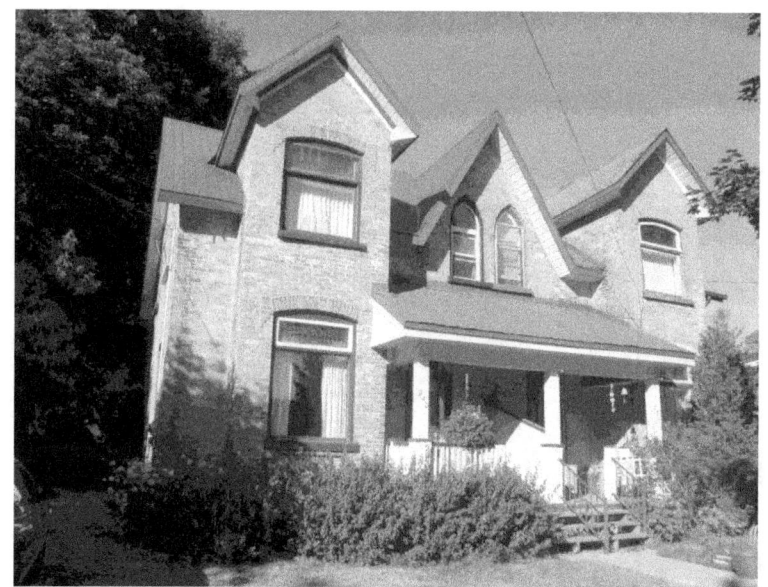

#240

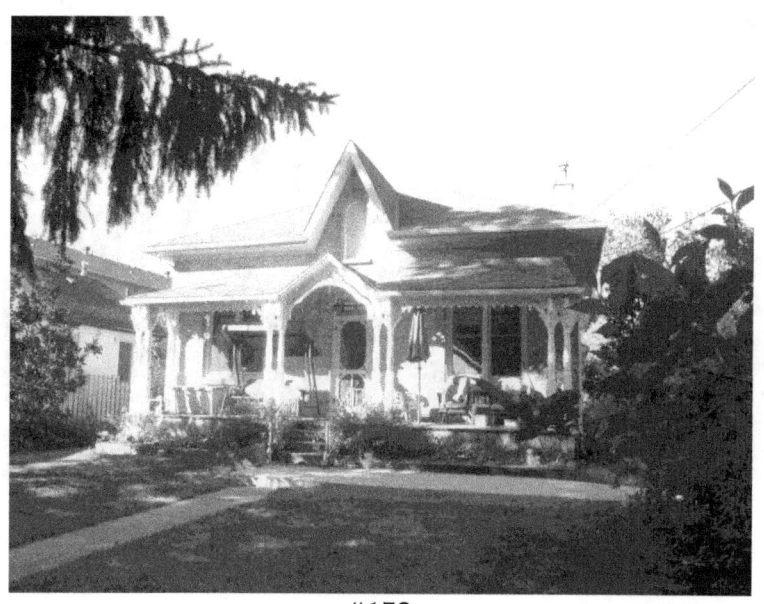

#152

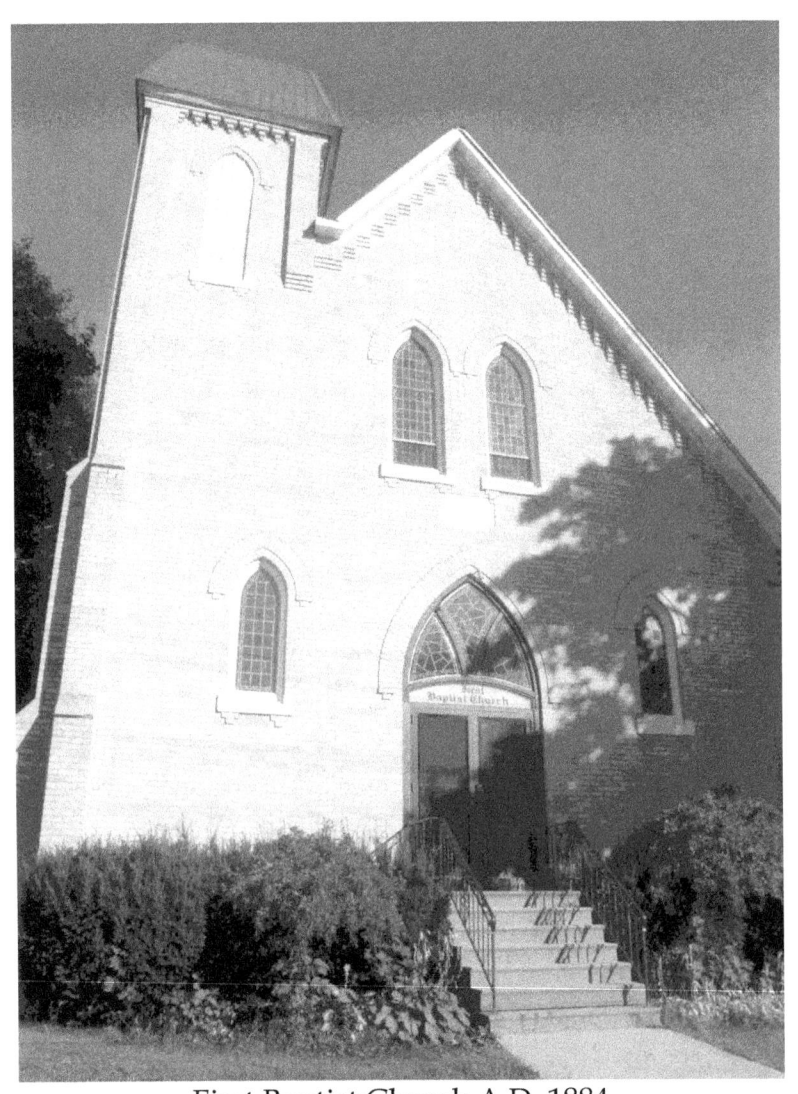

First Baptist Church A.D. 1884
116 Fergus Street North

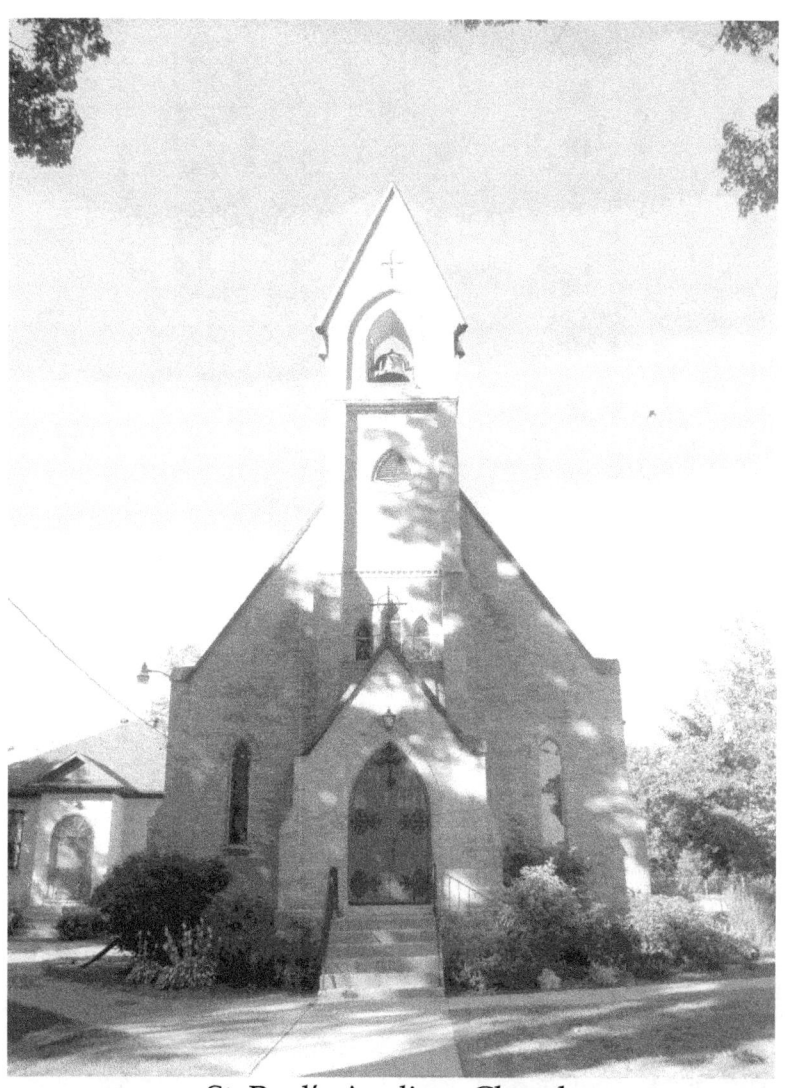

St. Paul's Anglican Church
114 Fergus Street South

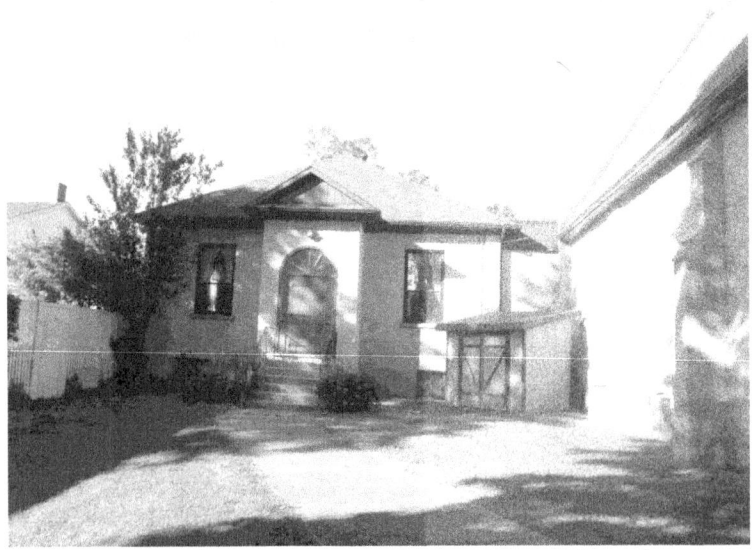
Manse beside St. Paul's Anglican Church

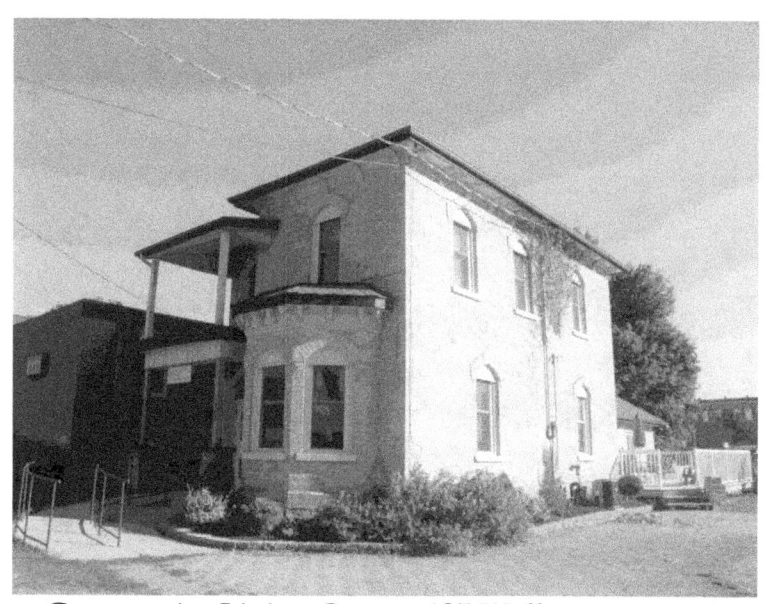

Community Living Centre, 135 Wellington North

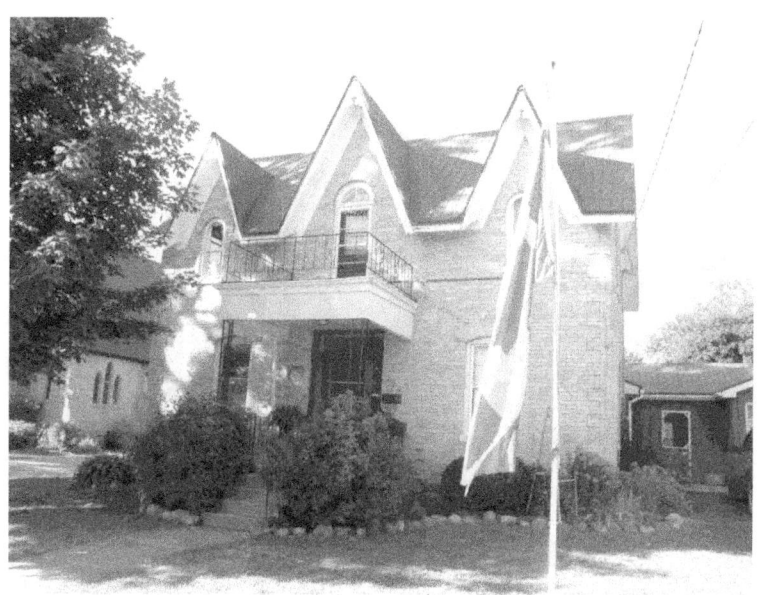

Mount Forest Centennial Home – 1879-1979
#124

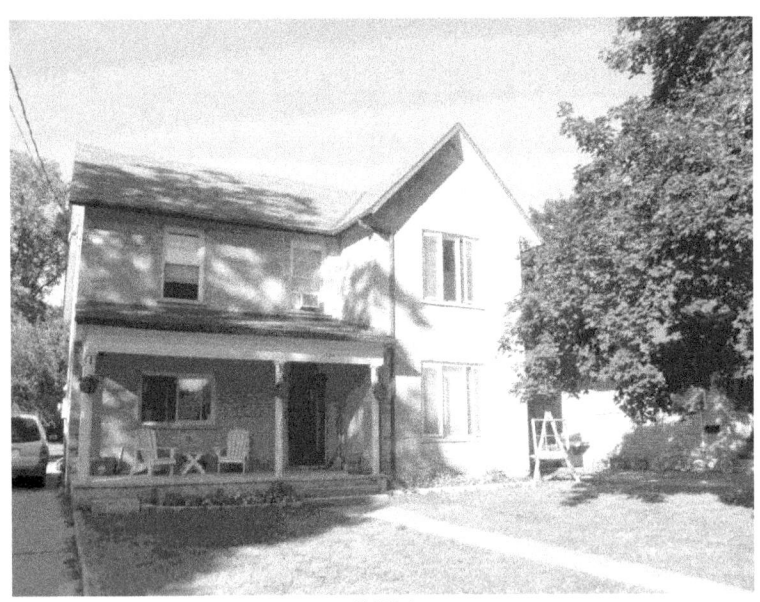

#154
Mount Forest Centennial Home – 1879-1979

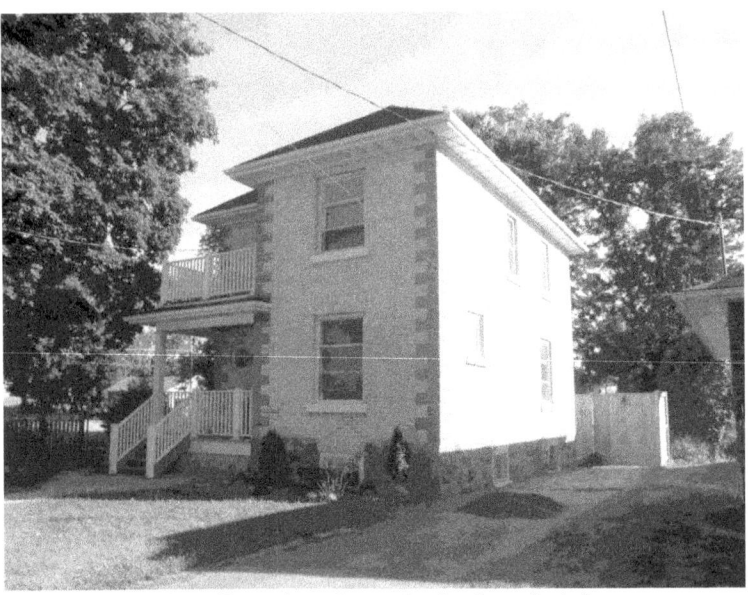

Made from local yellow brick with darker brick accents on the corners

www.ingramcontent.com/pod-product-compliance
Lightning Source LLC
Chambersburg PA
CBHW061523180526
45171CB00001B/310